CANDY

© 2005 Assouline Publishing
601 West 26th Street, 18th floor
New York, NY 10001, USA
Tel.: 212 989-6810 Fax: 212 647-0005
www.assouline.com

Translated from the French by Molly Stevens and the Art of Translation

Color separation: Gravor (Switzerland)
Printed by Grafiche Milani (Italy)

ISBN: 2 84323 749 1

CANDY

DELPHINE MOREAU

ASSOULINE

The Dawn of Delight

the Ancients didn't wait for us to discover the joy of sweets. The Greeks, Romans, Arabs and Egyptians made feasts with seeds, dried fruit, flowers and spices dipped in honey—the sugar of yesteryear. You might not know that the Romans took it to the next level with the dragée, or sugared almond, which they generously offered during public and private ceremonies. But, we don't know where they came from. Perhaps it was Julius Dragatus from the noble Fabius family, who openhandedly furnished them to celebrate births and marriages. Or was it the artisans from the city of Montpellier, the inventers of the *diadragum*, those almond candies from the beginning of our common era? We can't be sure. But, in any case, you only have to reread Petronius's *Satyricon* to discover that the Romans didn't spare their teeth.

The Romans also had their own chewing gum. We're not sure whether lovers would share it under the olive trees, but in the Mediterranean, chewing bits of licorice root was common. And, researchers working at burial sites have recently discovered a mixture composed of rubbery sap and honey, which the Ancients must have chewed.

In Asia, the indigenous population indulged in all kinds of sweets, using cane sugar as a base. The reason being, they could use the giant Bengali grasses, which could be found on site. The *Rāmāyana*, the famous Vedic poem from Antiquity, will entice you with its "tables covered with sweets made of syrup and sugar cane to suck on," yet another gum example from times past. Also from this time comes the famous halva, made of sesame paste and butter

known across the world, as well as barfi, a delicacy made from whole milk and flavored with cardamom.

During a journey to India in the fifth century, Darius, the Persian emperor, fell in love with "the reed that yields honey without the help of bees." He brought it back to his kingdom and his subjects began using it in recipes and especially in sauces. Later, the Turks tried their hand at sweetening, incorporating the precious liqueur into their biggest gastronomic achievement called rahat-lokum, which literally means "little bite of delight."

It was mainly through the Barbarian invaders that the taste for sugar developed in Europe. Sweets therefore didn't reemerge until the Middle Ages, at which time honey and sugar cane delicacies filled banquet tables and apothecary cabinets. In the meantime, Venice was importing "white gold" from the Middle East. Italian chefs consequently developed a true talent for candy. As for they crusaders, they first understood the gastronomic and economic potential of sugarcane when they were in Arab countries. Once various ports were conquered, sweets could be exported to the European courts and to their tables. Rabelais would later call sweets "muzzle harnesses," which can be translated as "a mouth load."

Above all, there were spices. Cloves, ginger, aniseed and juniper. But also almonds, pine nuts, and violets sautéed in a casserole with lots of sugar until balls formed. All these luxurious delights were mostly used for their therapeutic qualities. For one, they helped digest greasy meals. And also dishes served weren't always fresh. At the end of a feast, guests usually took special spices that were the candy of the time up to their rooms or to their host's quarters. Apothecaries, who provided gentle—and also hard—drugs, were well aware of the miraculous virtues of sugar. They prescribed sweet balls to soothe sore throats or upset stomachs, and also used

sugar to counteract the bad tastes of certain ingredients. Monks carried out similar experiments, even if it meant compromising their waistline. This is how the Grisette de Montpellier was created. This small candy made from licorice and honey also seems to have been used as currency between residents and the pilgrims traveling to Saint-Jacques-de-Compostelle. There must have made been too many! They were also used to bribe. The Happy Few from the Middle Ages offered them generously to judges in order to sway verdicts in their favor. Soon this candy became a staple of any festivity. In 1342, Cardinal di Ciccario hosted a Pantagruelian meal for the coronation of Pope Clement VI. The menu mentions "multicolor" candied fruit among the desserts.

●

I n French, candy is called "bon bon" (literally "good good"). It is said that, as a child, Henri IV cried "bon bon" upon seeing the sweets his father, the Duke of Vendôme was offering him. The candy phenomenon, which today fills our supermarket shelves, begins here.

During the same period, the history of sweets changed course when Henri II, king of France married Catherine de Medici in 1533. Hiding sugar was one of the vices of the future ironhanded ruler. Catherine brought master confectioners from her homeland to work in her suite. Her younger cousin Maria de Medici did the same when she married the same Henri IV. So, it's really thanks to these two women that new delights from Italy came to France and spread to all the European courts. And of course, the huge sugar cane crops in the New World incited the conquerors to encourage the use of this "white gold."

It was during the Renaissance that candy as we know it emerged. What were they nibbling on then? A lot of candied fruit— oranges, lemons, and flowers. And the technique for preparing them vastly improved during this period. The first Roudoudou quince jelly pastes were offered in small wooden boxes nick- named "troublemakers" and were sucked on by men in high places. Under Bourbon rule, it must have been impossible to resist the candied fruit known as the Sept-en-Gueule. This specialty made with seven miniature pears could simply be popped in the mouth in one piece. But only if you weren't already sucking on a pastille made by Giovanni Pastilla, a Medici protégé and the inventor of hard candy pieces. He creatively added fresh, romantic flavors including vanilla, wild rose, strawberry, rasp- berry, angelica, iris, heliotrope and carnation. Then the Conquistadors brought cocoa and coffee to Europe, which opened the door to other new and wonderfully devastating flavors.

A bit later, another specialty chef caramelized a new kind of sweet: the praline. During the Fronde revolts, the Count de Plessis-Pralin hosted a banquet to debate the thorny conflict. During dessert, he passed around almonds browned in sugar, which his head chef had invented when he saw one of his kitchen boys snacking on almonds with bits of caramel. The guests imme- diately named the candy "praline." This gallant Count then offered it to his mistresses, who made them popular in the courts. Eventually the chef left his patron to open his own business in Montargis.

The well-to-do from the seventeenth century also gave each other Calissons from Aix-en-Provence. This was candied fruit and almond paste flavored with orange blossom and covered with a slice of unleavened bread. In French southern cities, priests would offer it as the consecrated bread during Christmas mass.

You should hear how the Marquise de Sévigné speaks of them greedily in her letters.

and what about England? Most families indulged in candy inspired by French and Italian recipes. At one time they were even nicknamed "kickshaws," meaning "something or other." But the royal family preferred chewy fruit balls rolled in icing sugar—jellies—to specialties from abroad. The ruling class ate them so much that they had black teeth instead of pearly whites. North American colonizers from this period also shared this taste for sweets, but they had to contend with molasses extracted from crystallized sugar, which soon became too expensive to import.

So, the Anglo-Saxons weren't big candy inventors. It wasn't until the eighteenth century that George Dunhill, the British pharmacist, finally made the first licorice candies. He had a surplus of this medicinal roots and therefore mixed it with sugar and flour. His clients were thrilled with the result, and doctors later prescribed it to patients who wanted to stop smoking. According to certain historians, it was trade between Portugal and Japan that brought sugar to the country of the Rising Sun. Soon the emperor's chefs were sweetening wagashi, the tiny age-old pastry made from rice. Offered during tea ceremonies, these genuine works of art were most often shaped into flowers.

India already had stores that specialized in sweets at the beginning of the seventeenth century. They offered all kinds of delights— mostly pastries, but also seeds browned in sugar and butter.

In Europe, the first candy shops didn't open before the end of the Enlightenment. The oldest one still standing in Paris is called

La Mère de Famille. It opened its doors in 1761, at a location near the Les Halles area. Glass bins lined up along the wall tempted clients with sweets that were sold by weight. And high society sometimes preferred to meet in such reputable establishments instead of seedier cafes.

Now that there were places devoted to candy, once the specialty of apothecaries only, sweets broke out of high circles and landed on everyone's table.

The Era of Funny Machines

the nineteenth century neither was or wasn't a golden age in the history of candy. With sugar beets being widely farmed in Europe, the raw material used to make candy became much less expensive. Candy therefore soon became something a growing part of the population could indulge in. Furthermore, the industrial revolution yielded several innovations for candy. It was the era of candy machines, not unlike the ones described by Roald Dahl in his delicious book *Charlie and The Chocolate Factory.* To top it all off, confectioners were letting their imaginations run wild. In a single century, they would create sugar recipes that were out of this world, each one more sophisticated than the next.

Many of these sweets owe their existence to French "glyco-files," the title adopted by sugar enthusiasts. For example, marshmallow. Marsh mallow root had been used in Great Britain since the Middle Ages to cure colds and urinary problems. Small

bits would be chewed at a time. The French soon came up with the idea of mixing it with whipped egg whites and sugar, which give it the soft texture we know it to have today. Starting in the twenty-first century, however, gelatin was used instead of marsh mellow root.

France also seized the opportunity to concoct many local specialties, like the Bergamote de Nancy and the Forestine de Bourges. The names alone make you salivate.

In Cambrai, the young Émile Afchain, who was then an apprentice in the family candy business, embodied the experimental spirit of his time by testing new candy recipes. One of them was perfected around 1850 and took the form of a charming yellow and white square that tasted of mint. Legend has it that his mother first regarded it as utter foolishness. But she must have changed her mind rather quickly. Dressed in traditional costume, she soon appeared in advertisements, waving the candy, and exclaiming, "But would you taste this!"

During this time, the Anglo-Saxons dove headfirst into the candy industry. The French had the gall to invent a machine to make sugared almonds! So what?! The British were going to invent a machine to make drops. These candies made from powdered sugar, lemon juice and flavored with fruit had been made by hand since the eighteenth century. But the machine made eccentric shapes possible: fruit, flowers, fish, insects, and musical instruments. The Nelson's Button was a very popular example during Victorian times. Made with egg white and colored pink or red, it alluded to the bloodied coats of the Trafalgar heroes. Basically, it was patriotic candy!

In the United States, self-made men also tried their hand at mass-producing candies of all kinds. They were soon nicknamed penny candy, because of their modest cost per piece. The most known

examples are the black mints called Black Crows, chocolaty Tootsie Rolls, and fruit-flavored Charms Squares, and of course caramel Mary Janes made from molasses, butter and peanuts. These brands, which are symbols of the past today, were also known as "theater candies," and were meant to literally be enjoyed at the movies. But let us return to the nineteenth century, when two new forms of truly revolutionary sugar temptations came into being.

●

In Bristol, Francis Fry and the family chocolate business that bore his name introduced the Chocolate Cream in 1866. This was a bar of dark chocolate filled with crème de menthe. It was essentially the first candy bar. Through their tenacity, chocolate makers—especially Swiss ones—were for some time already able to produce solid forms of chocolate. Today's Chocolate Cream, the one that ladies slip into their purses in case they need a snack, doesn't share the same recipe of yore. But the mould remains.

In 1893, Milton S. Hershey, known as The Caramel King in Chicago, traveled to Europe where he discovered these extraordinary sweets and the machines needed to make them. It inspired him to invent the milk chocolate bar in 1900. He made a killing from it, and soon began combining chocolate with other mouthwatering ingredients. The bars were initially meant to be eaten during baseball games. But, during the First World War, the army ordered that soldiers be given the bars as part of their Daily Ration, which was meant to offer a good daily dose of calories. When they returned home, the soldiers didn't give up this small little treat.

Another unusual wonder from this time was chewing gum, a pure product of the American melting pot. (It is, however, amusing to note that a dictator played a somewhat significant role in its invention...) In the 1860s, the general, and occasional Mexican head-of-state, Antonio Lopez de Santa Anna was chased out of his country because of his rough ways. He brought loads of chicle with him to his exile among the Yankees and intended to sell this sapodilla tree gum as a substitute for rubber. In the American Indian tradition, he liked to chew small strips of it. Santa Anna's business failed, but in the meantime the Mexicans changed their minds about him and took him back in the 1870s. He returned home, leaving what he brought with his American partner, Thomas Adams, who upon seeing a young girl chewing on some paraffin wax, remembered Santa Anna's own habit. He flavored his gum with licorice and persuaded a pharmacist to buy some instead of the paraffin wax, and at a lower price. Soon his Black Jack Gums would be sold in every good drugstore. This was also a time when manufacturers strove to create nice packaging for candy. Confectioners first introduced painted glass or ceramic boxes, illustrated with melodramatic or moralistic scenes that corresponded to what was inside. Most were offered during religious ceremonies like baptisms and weddings, and some even bore aphorisms like "Meditation makes it better." Richard Cadbury, a romantic with a flair for business, manufactured the first box of chocolates meant to be offered for Valentine's Day. It was made of cardboard and was shaped like a heart. Finally, in 1871, when metal engraving was perfected, packaging reached new heights. All the French specialties would thereafter be offered in collectable metal boxes, including Anis de Flavigny and Zan licorice (the name was inspired by the child's expression in French, "Maman, z'en veut" (Mom, I want zome)).

Both a source of profit and adored by all, candy soon took on an important role in the great American national holiday, declared at the end of the nineteenth century, Halloween! Just like now, children would visit their neighbors and cry out, "Trick or Treat." Nowadays, in the western world, candy can cheer up anybody's day—or almost anybody's.

Two Major Brands from Another Planet

between the wars, two big brands came onto the sweet scene. They delighted young and old alike and still find a place in our hearts and stomachs today.

In 1920, the confectioner from Bonn Hans Riegel founded Haribo, short for "Ha" (Hans), "Ri" (Riegel), and "Bo"(Bonn). Two years later in his laundry room, he put his first Tanzbar or "dancing bear" on its feet. This candy was 8 inches long and was made from jellied gum, which was not common at the time. His wife delivered the Tanzbar by bike to their first clients. The business was so successful that on the eve of the Second World War, it had more than four hundred employees and was producing new kinds of candy, especially varieties made with licorice. "Haribo macht Kinder froh" (Haribo makes children happy), declared Riegel, who himself mustn't have felt too upset. Haribo products continue to be manufactured today and are distributed across the globe.

At the time that this German entrepreneur was marketing his bear, an American named Franck C. Mars opened his fourth candy shop.

The fact that the three first ones failed apparently didn't stop this brave man! He concocted a cream made from milk, nugget, caramel and chocolate, which his clients loved. When his son Forrest came to work with him at the family business, he suggested selling the cream in individual bars. And so, the Milky Way was born. Americans went wild for this cosmic candy bar, which triumphed on the chocolate market. During the Great Depression, candy bars even often served as a substantial and inexpensive meal substitute. The Mars men seized the opportunity to launch the famous Snickers bar. Then Forrest Mars decide to take off on his own. He moved to Slough, in the outskirts of London, and set out to offer this bar that was so popular in the United States to the English.

He did have competition. Francis Fry, who had financial problems, put dozens of new brands on the market, including the 1929 Crunchie bar, which was covered in milk chocolate and was reminiscent of honeycomb. This didn't stop the young Mars. In 1932, he modified the Milky Way recipe, adding a good amount of sugar to please the British palate. Then, the confident Forrest gave it his family name. The entrepreneur didn't skimp on advertising and marketing. The following year, when the Queen Mary first set sail, the chocolate bar was distributed to all passengers along with a deck of cards to celebrate the event.

Franck C. Mars died in 1934 and bequeathed the company to his second wife. Vexed, Forrest registered his own brand in the United States. He called it M&M's for Mars & Murrie, the name of his partner, also a big name in the business. The first product these newcomers launched were the very round chocolate candies dipped in sugar of many colors we know today. They were almost identical to British Smarties. And Forrest came up with an unforgettable slogan, "Melts in your mouth, not in your hands."

In Great Britain at the time, there was less and less of a variety of chocolate candy to choose from, as if chocolate were trendy. In the 1920s, the fad was to give a 5 O'Clock Fry in a polished tin teapot. In 1936, Rowntree, a respected name in British chocolate "signed on" to sell assorted candies in big boxes. Colorfully wrapped goodies called Quality Street turned heads. Rowntree soon became a fixture in the chocolate world, coming out with other classic candy delights. There was the Kit-Kat, which most likely got its name from the Kit Kat Club of the 1920s; Aero, a chocolate bar that was literally airy; Rolo, the caramel filled candies; and Smarties, which from the start came in seven different colors.

For those who didn't like chocolate, Alfred and Mauric Matlow developed a whole range of acid drops, like the famous Fruit Fizzers, the round, pastel-colored candies in clear wrappers. Along with Navy Mints (a forefather of Polo), Double Lollies, and News Refreshers (mint-filled caramels), all of which were made by Swizzels Matlow, the manufacturer of Love Hearts, which really won couples over. These candies had messages stamped on them like "Take me in your arms" and "Kiss me." Today, on its website, the company even offers precious boxes of Love Hearts for newlyweds.

In France, Pierrot Gourmand was the brand that would conquer the masses. In the 1920s, while strolling through a funfair—where sugar enthusiasts traditionally let their imaginations run wild—the confectioner Georges Evrard saw children sucking on sticks of barley sugar. They left the sticks partially covered to keep their hands clean. Evrard, then the head of a small business, had a revelation. The lollipop. He immediately began producing hard sugar candy shaped like a spearhead and attached it to a stick made of cane from Madagascar. And so the Pégé lollipop was born! And this caramel flavored wonder could be bought for pennies. Who could resist?

In fact, Charles Dickens already mentions that lollipops existed in England in the nineteenth century, and they could be found in the United States too. But, the legend of candy, which is maliciously maintained by its own manufacturers, won't be burdened with such details.

There's always a strange bird taking flight in the candy aisle. It's the singing magpie brand called La Pie Qui Chante. This little company, founded by Jean Cabanon from Marseilles, was named after a cabaret that was very popular in Montmartre before the war. After 1925, with help from its owner Georges Cornillot, who was from Lille, it made a name for itself with a caramel called the Galéjade. In 1936, La Pie Qui Chante sang its first tune—caramel squares dipped in black chocolate. Its initial campaign presented an African woman in a bubu, which therefore affiliated the candy with life in the colonies. It was because of this popular item (with dangerously addictive ingredients) that children began to appreciate the magpie, the brand's symbol, rather than fear it. Ah, the magic of candy!

Bonbecs: The French Penny Candy

In his famous 1960s song, Jacques Brel celebrates old-fashioned candy that came in beautiful boxes and that was meant to be offered to ladies. But, the post-war years marked the dawn of what became known as *bonbecs*. "Economical, popular and absolutely chemical," as Anne Rozenblat and

Alexandre Révérend wrote in their book, they gradually dethroned their glorious forefathers from the "glyco-file palace." Children bought them by the piece at the store with the milk money. And parents would spell out the word c-a-n-d-y in front of their children so as not to get them desperately excited.

Oftentimes, color and wrapping outdid taste. Sometimes candy was even a toy with sugar in the middle. As the potential ill effects of sugar on the health became known, candy became a guilty pleasure, one that was all the more desired because of it.

Let's close our eyes and sample the best-known childhood treats from the boom years following World War II in France.

In 1954, a certain Welshman, who worked at the chocolate company named Delespaul-Havez, made a chocolate caramel from the surplus of cocoa powder. The candy that came out of it, named the Carambar, was about two inches long, sold for a few pennies, and had a yellow wrapper. The famous jokes that accompanied them earned a reputation throughout the country, whether they were taken literally or because of their insinuations!

The Malabar then came onto the scene. This candy was brought to the Liberation by the G.Is. It wasn't so much the gum itself that gave the Malabar its appeal, it was mostly the packaging. Inside there was a tattoo you put on by licking it. Kids were drooling!

The candies mentioned above retained a traditional consistency. But, there were others that had totally disconcerting appearances and tastes. For example, kids often had Coco Boer at the playground. These were small round metal boxes of many colors that contained a yellow powder flavored with licorice. And you ate it with your fingers! Another very bath-like powder was the Mistral Gagnant, which the French singer Renaud sang about in his 1985 hit. It preciously came in a vertical envelope. And once you swallowed the powder, the word "winner" would sometimes appear

at the bottom of the package, which meant one free Mistral could be redeemed. These two dentist's nightmares have unfortunately disappeared.

Won over by chemical candy, children soon had a new way of buying sweets, one that was independent and safe from disapproving stares. The first candy vending machines were painted red and first appeared at funfairs and along the walls in some major cities, and eventually next to French cafés.

When candy began to globalize, the industry went through a creative spurt that realized every child's wildest dreams. The major players must have somehow kept a young spirit alive. Edward Dee, an Englishman who lived in the United States, is an example. At the end of the 1940s, he marketed sweet fruit-flavored candies especially for Halloween. Offered in a variety of pastel colors, they were then sold in rolls of fifteen for a penny. He stole the name Smarties from Rowntree, which never took care to trademark the brand abroad. And he used the English Swizzels Matlow recipe that distributed the candy in Europe under the name Fizzers. In 1958, Dee designed the Smarties necklace, which was the first wearable sugar jewelry. Their recipe was also used to develop an edible lipstick for little girls. Who among our readers hasn't pouted in front of a mirror with this candy? That same year, Spain burst onto the scene with what would become the world's favorite lollipop: The Chupa Chup. "Chups" was the sound of pulling the lollipop out of your mouth and "Chupa" means "suck" in Spanish. Its logo, designed by Salvador Dalí, played a huge role in its fame, as did its round shape that was easy on sensitive palates.

In terms of chocolate, the Italian Ferrero "hatched" the Kinder Surprise in 1974. This egg, with milk chocolate on the outside and white chocolate on the inside, had a little figurine or small gadget that could be assembled in the middle. Sometimes doing so was so complicated, despite the instructions, that parents had to help. So, there was always a moment of intense collaboration.

In terms of the second half of the twentieth century, the Pez dispenser was undoubtedly the most popular candy-gadget among the flood of innovations. These peppermints (they were called PfeffErminZ in German) were developed by an Austrian, who intended them for smokers before the war. In the 1950s, Pez packaged them in hygienic dispensers topped with the head of a Walt Disney character. Then they were given feet to stand on. In France, in the 1960s, the newspaper *Pif Gadget* offered a Pif Pez dispenser! Pez-mania spread throughout the world and it hasn't weakened with time. The fact that a manufacturer of stereo accessories recently sealed a deal with Pez is proof. What they want to do is market an MP3 player that could also be a dispenser. What a fine line exists between candy for children and "grown ups!"

Nevertheless, candy made especially for adults emerged after the war, especially in Great Britain. In 1948, Rowntree launched Polo, a mint with a hole to freshen your breath. Twenty years later, Ferrero successfully backed the concept and created the Tic-Tac.

Rowntree also pushed the envelope with its delectable After Eight in 1962. This extremely thin mint-filled dark chocolate came in a black tissue sachet. It was the first sweet specifically meant for nighttime consumption!

During the oil crisis, Haribo candies were all over Europe. On both sides of the Channel, parents and children alike found comfort in sipping bottles of Cola covered in granulated sugar that made it look like shining glass. The Germans, French, British and

Austrians filled their mouths with creamy Tagada strawberries, sparkly crocodiles and even sour French Fries.

I n short, all of Europe stuffed itself with gummy candy. Health experts began to warn the public of the hidden dangers of candy. And its forbidden quality only grew. As early as 1966, when France Gall sang Serge Gainsbourg's *Les Sucettes* in her syrupy voice, dirty minds began to churn. Was sugar a guilty pleasure? Its appeal increased tenfold. Dangerous but irresistible, candy became an allegory for sex in the collective unconscious. In the 1980s, Rolf D. Schwartz, a New York confectioner, even gave shape to this idea by making pastries and candy in erotic shapes.

In 2001, Francis Miot, a confectioner in Pau in southwestern France, made a name for himself with his cute Coucougnettes de Vert Galant, named best French candy by the Salon International de la Confiserie.

On that occasion, the men remembered one of the meanings of the French word "bonbon." No visual reminder was necessary, however, to delight in tasting one. Those who still have doubts should go out of their way to taste the irresistible Cassissines from Dijon. This tender fruit paste filled with cassis liqueur will make you swoon with pleasure.

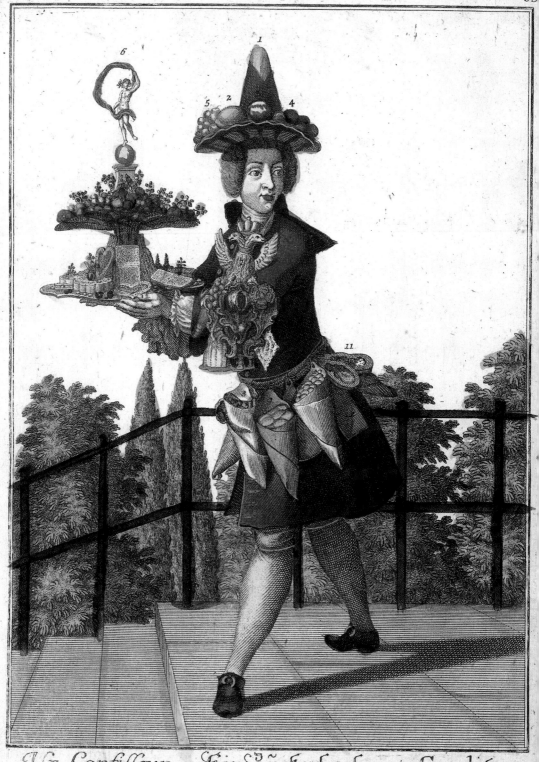

Un Confisseur. Ein Zuckerbacker od: Candifer.

1. *Un pain de sucre.* 1. ein Zückher Hüth. 2. *Citron.* 2. Zitrone. 3. *Orange.* 3. Pome

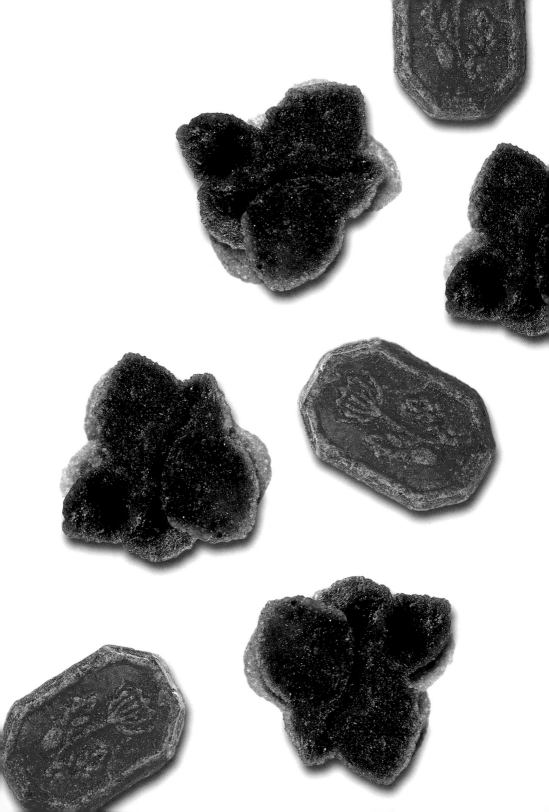

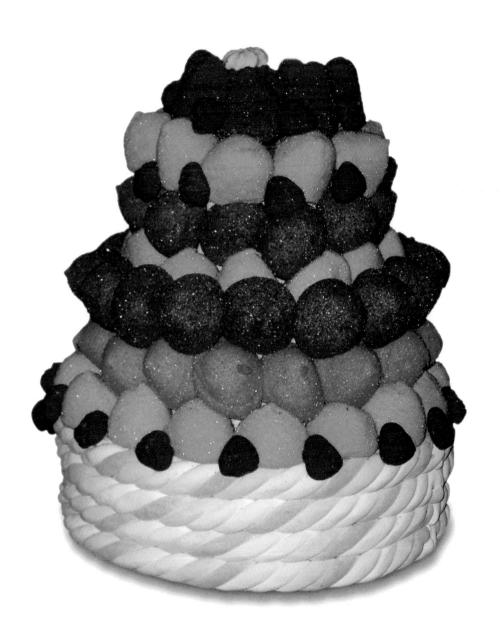

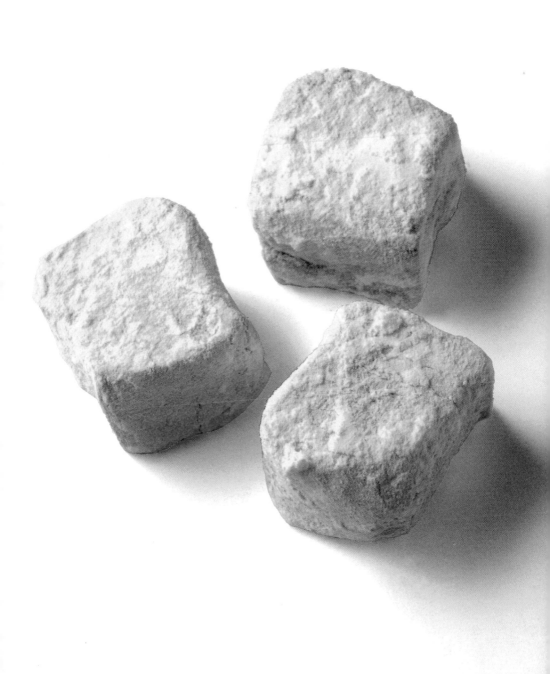

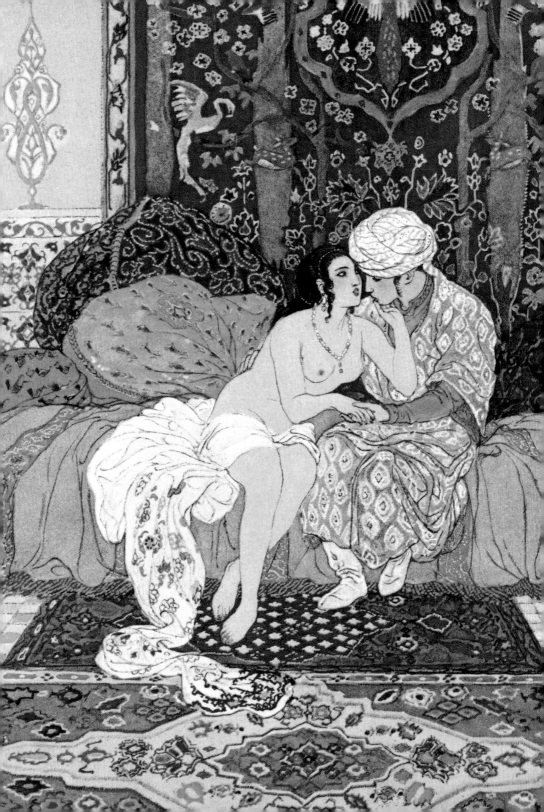

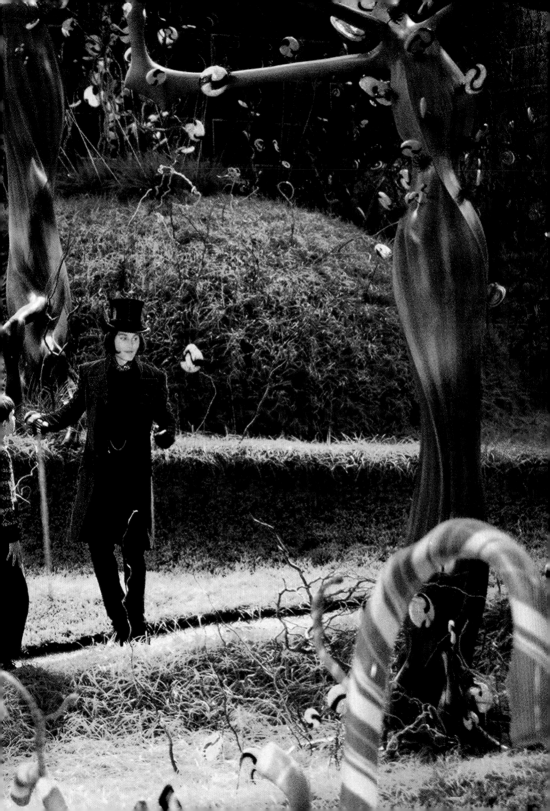

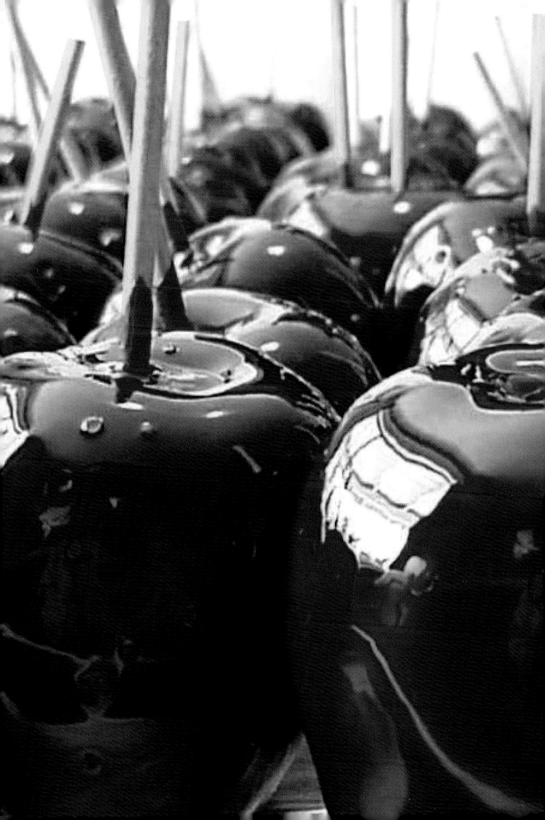

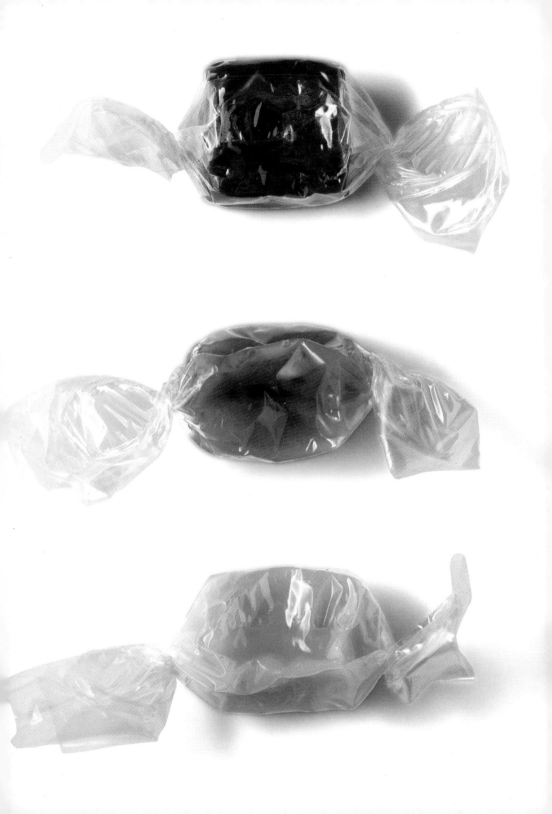

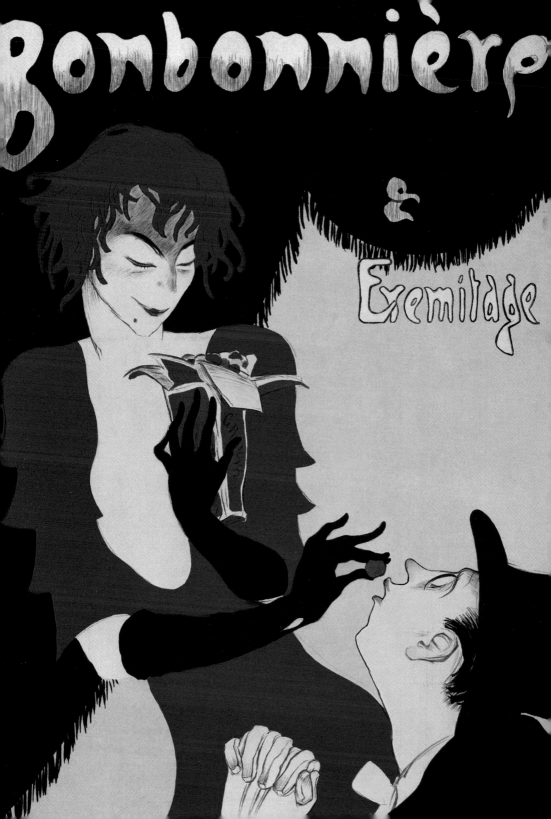

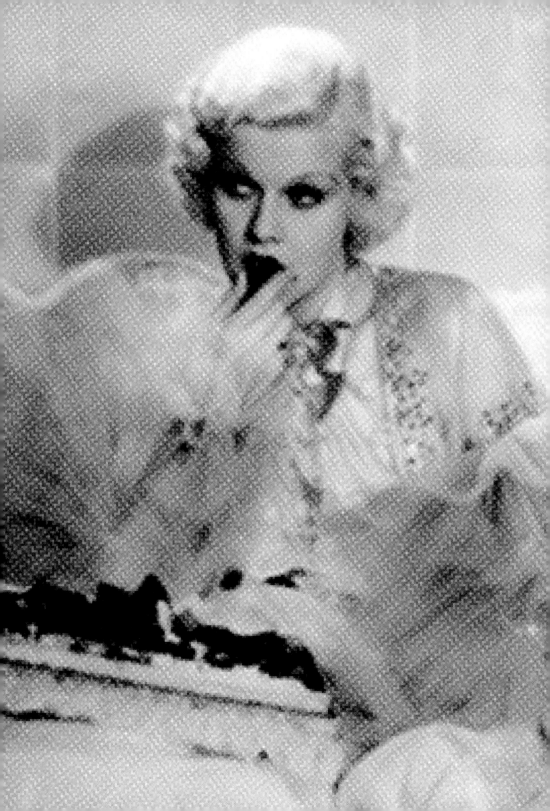

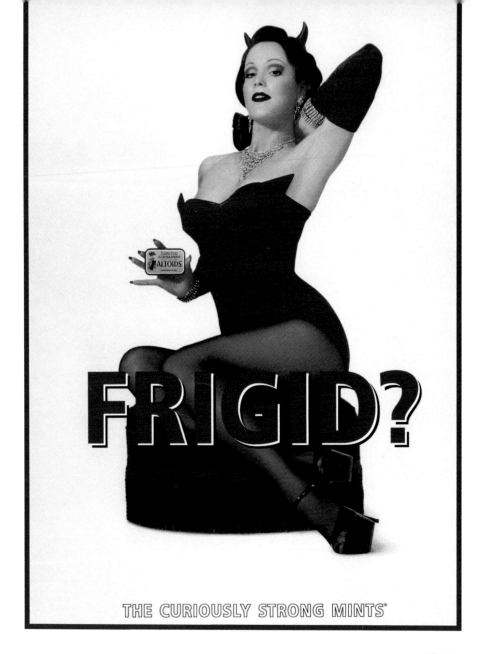

FRIGID?

THE CURIOUSLY STRONG MINTS®

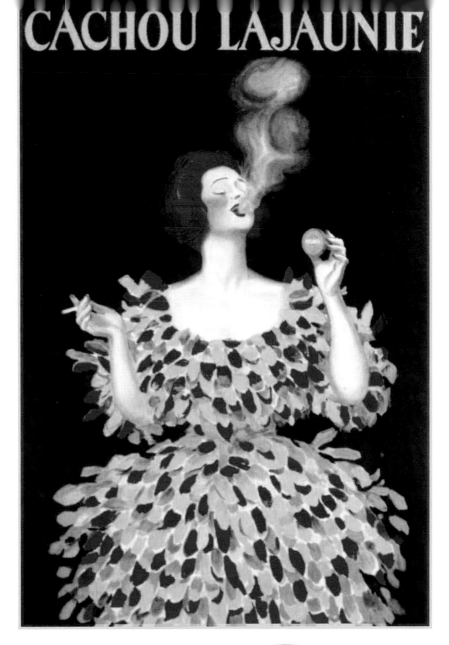

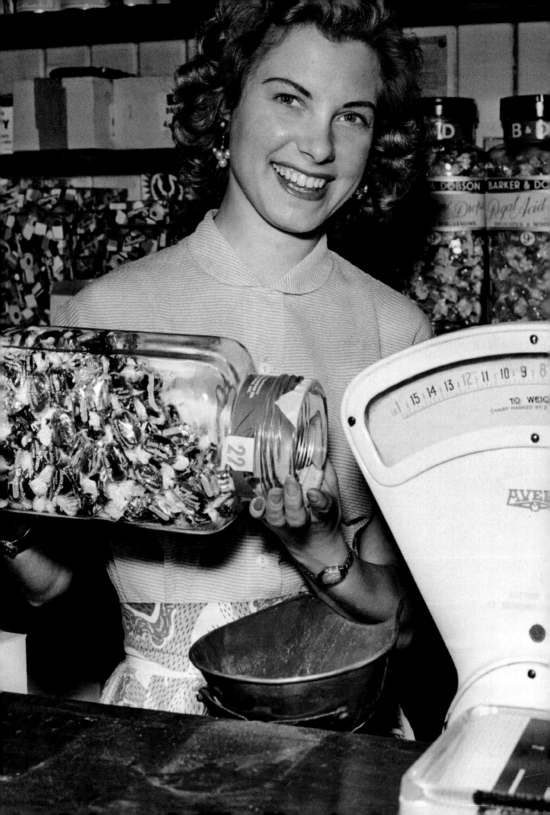

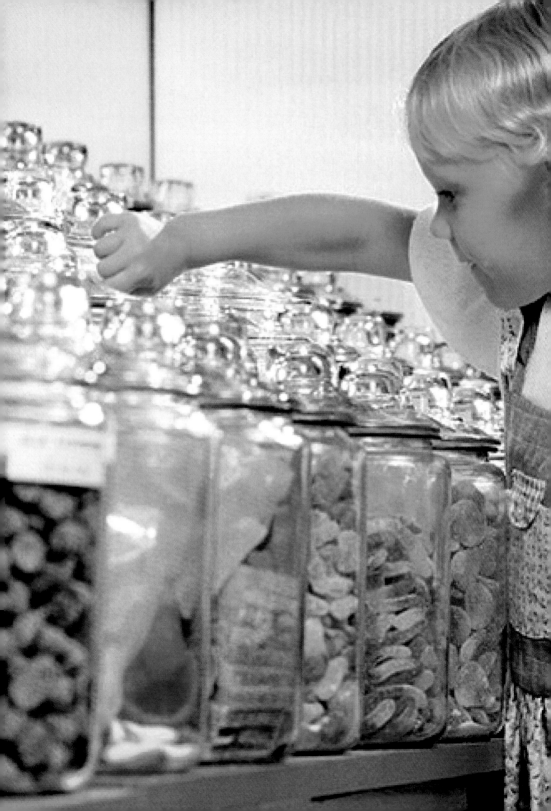

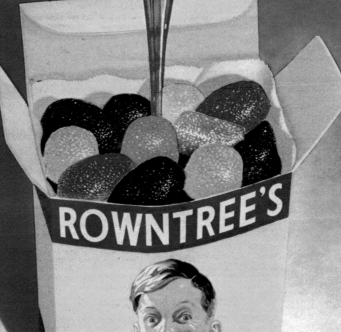

ROWNTREE'S

FRUIT PASTILLES

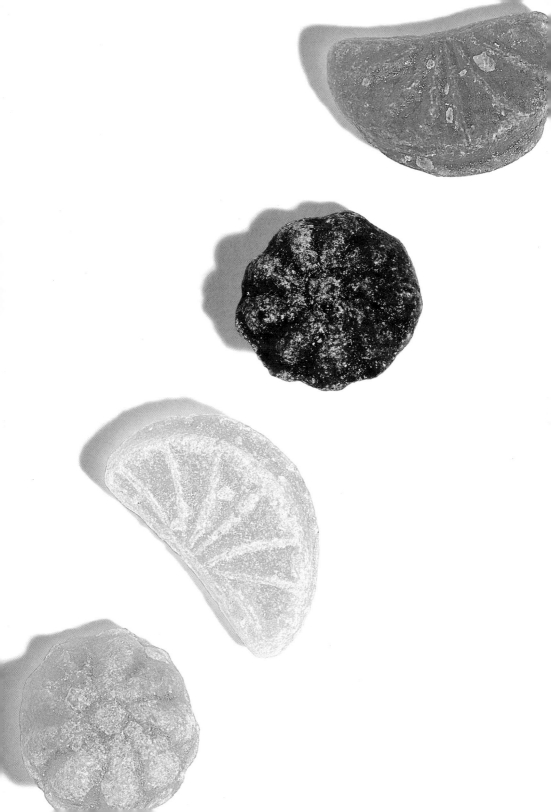

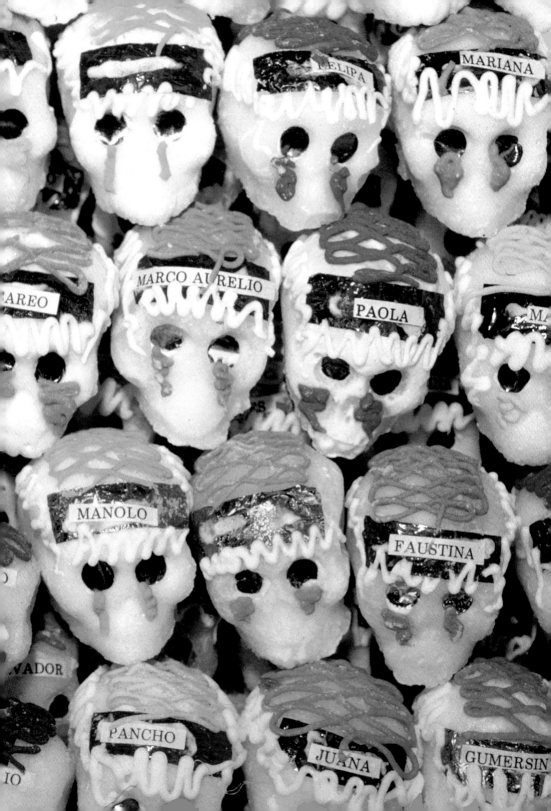

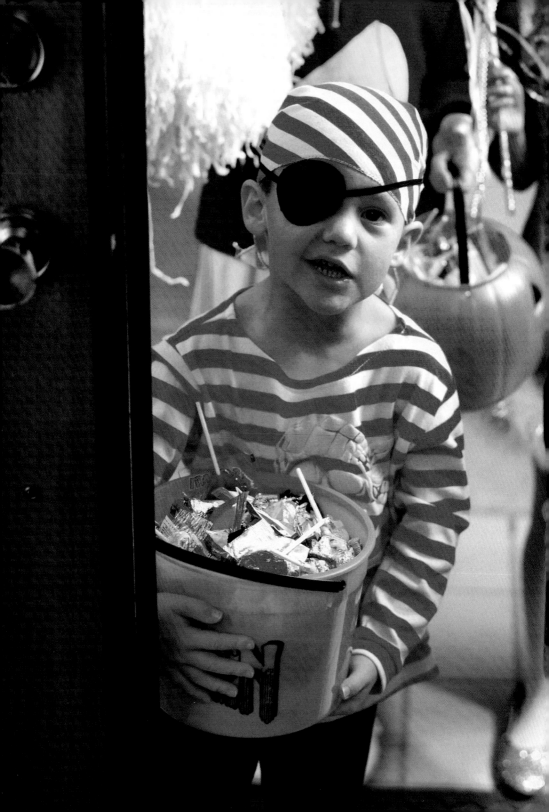

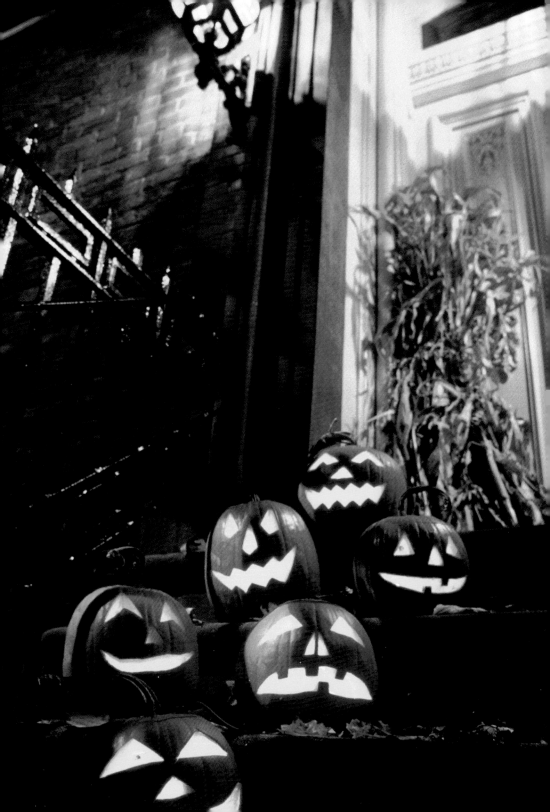

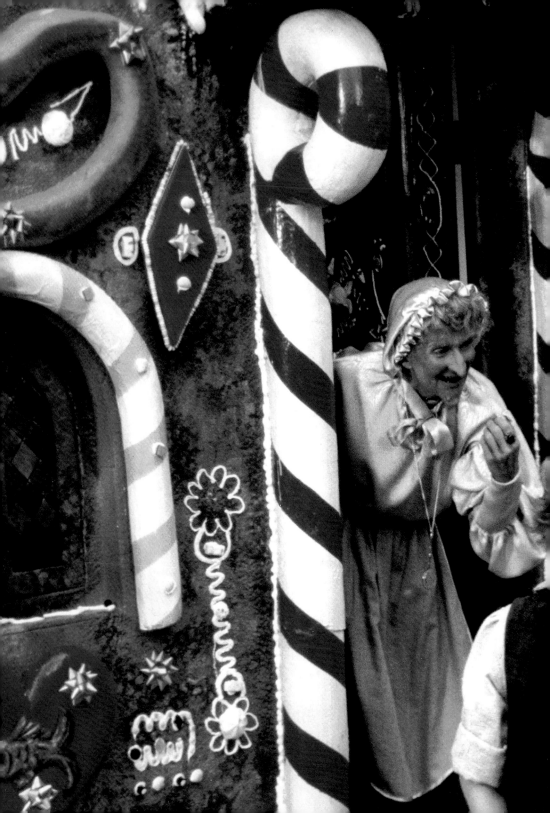

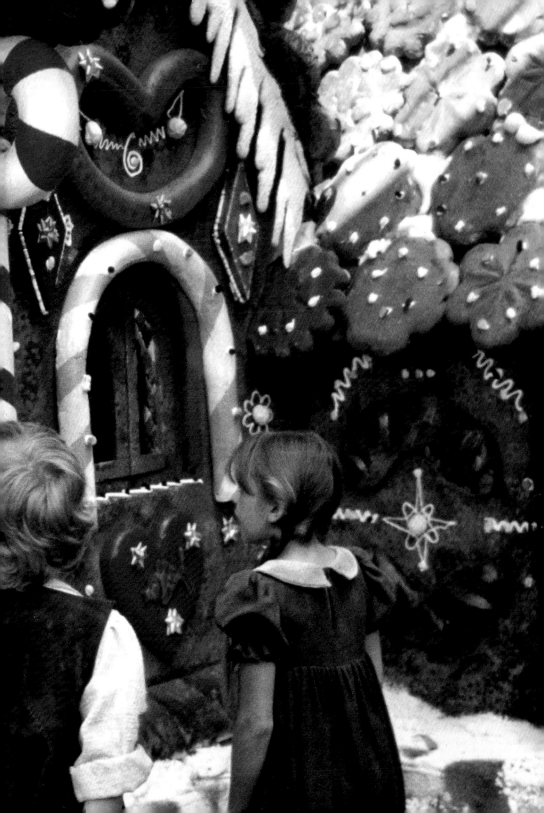

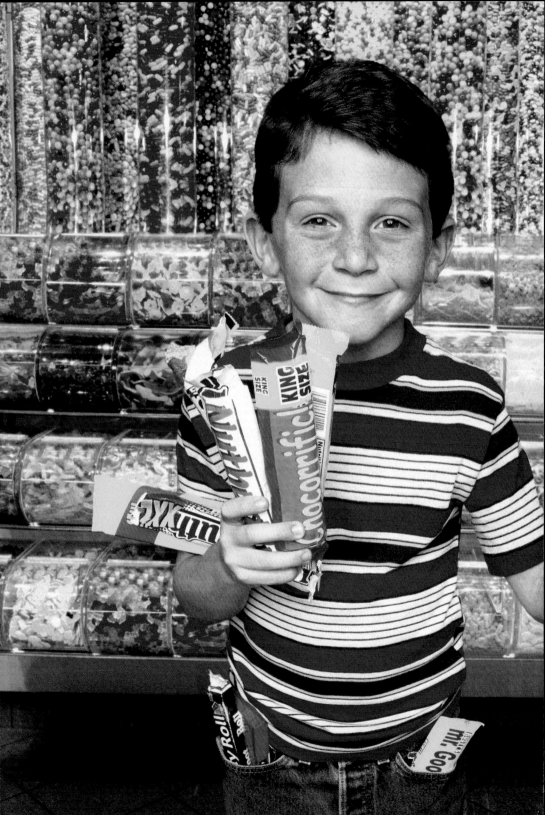

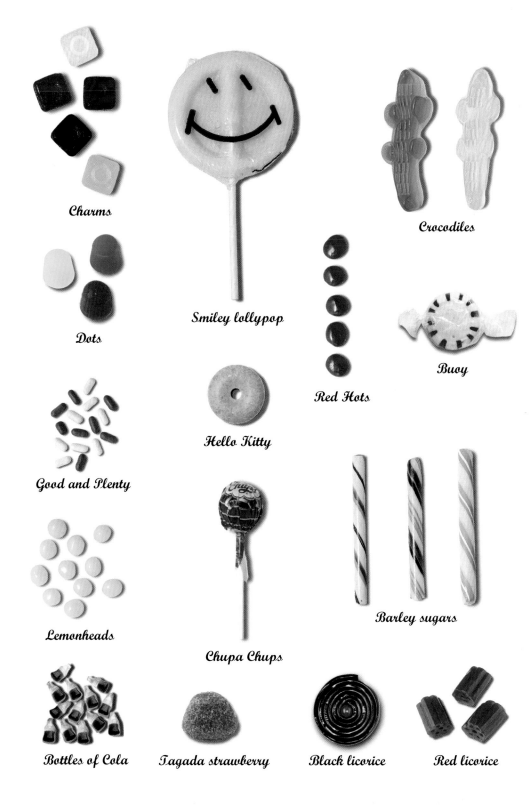

Charms

Smiley lollypop

Crocodiles

Dots

Red Hots

Buoy

Good and Plenty

Hello Kitty

Lemonheads

Barley sugars

Chupa Chups

Bottles of Cola

Tagada strawberry

Black licorice

Red licorice

TOOTSIE ROLLS

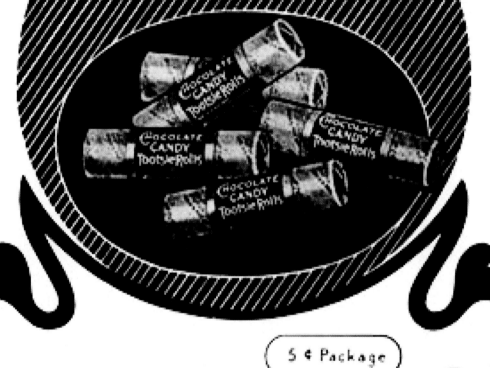

Toostie Rolls stand any weather -stand any test - and sell at any times. All this we garantee.

Packed 22's and 100's
Allow 5c. and 10 c. packages.
Samples on request.

5 ¢ Package

Chocolate Candy Toosie Rolls

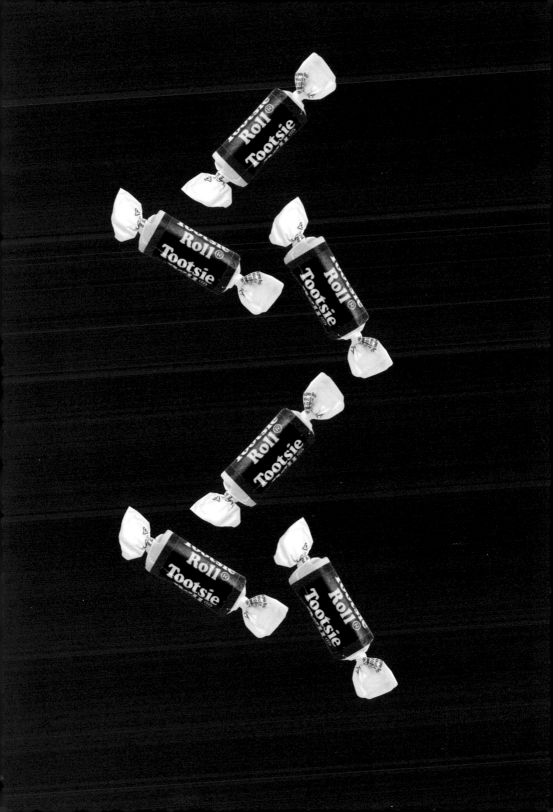

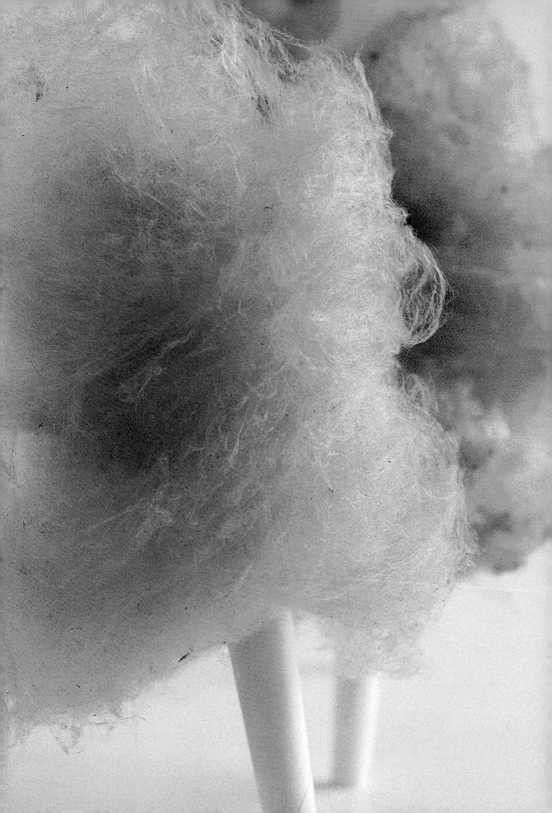

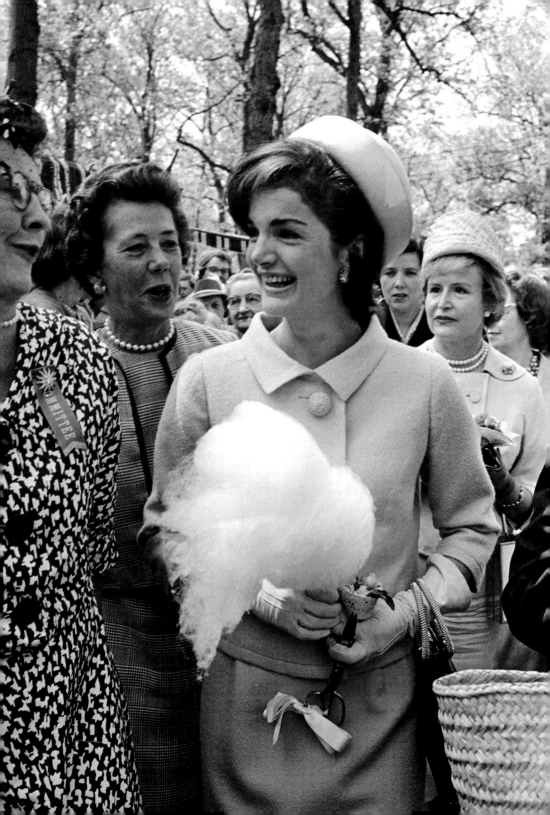

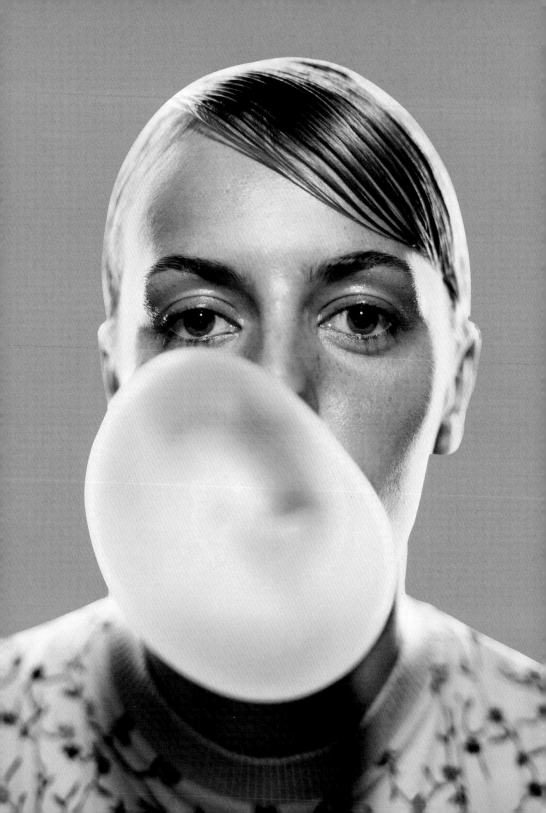

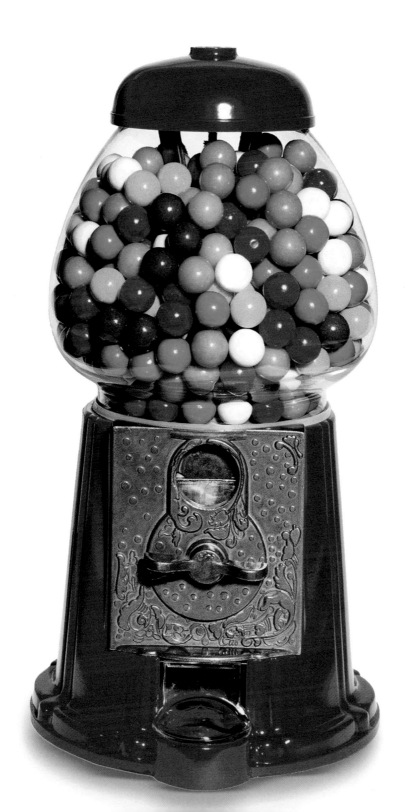

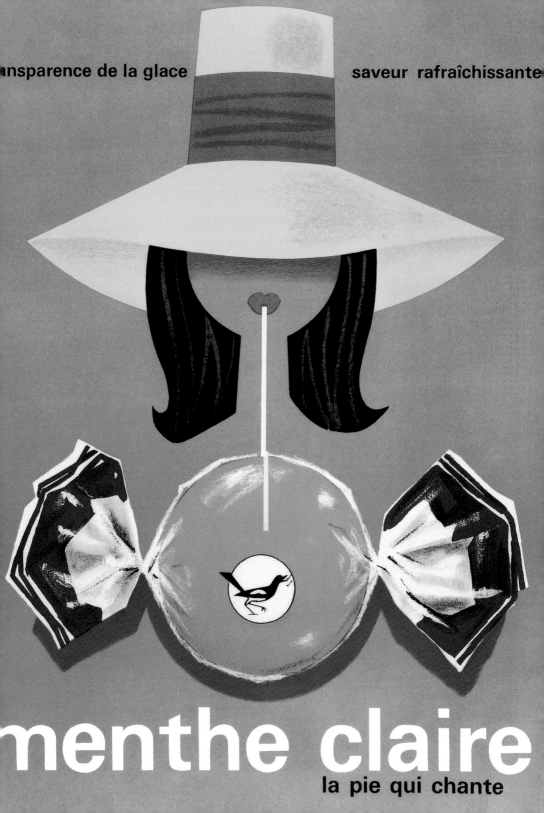

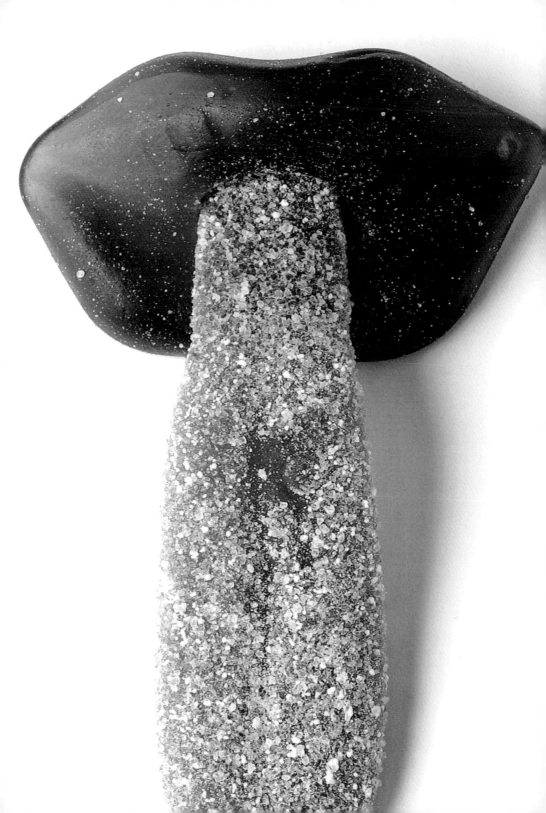

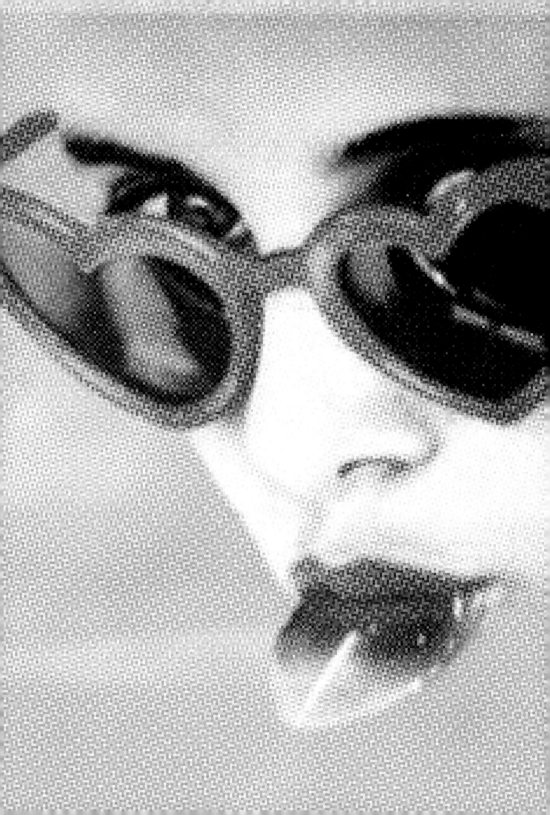

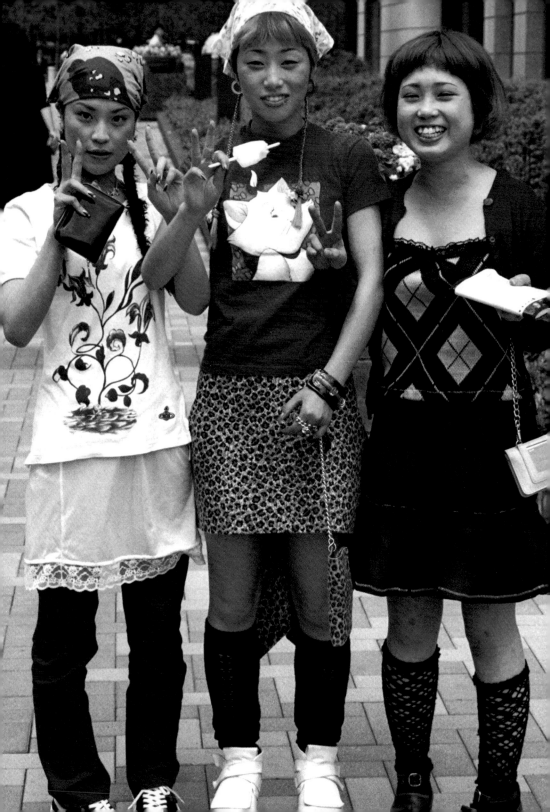

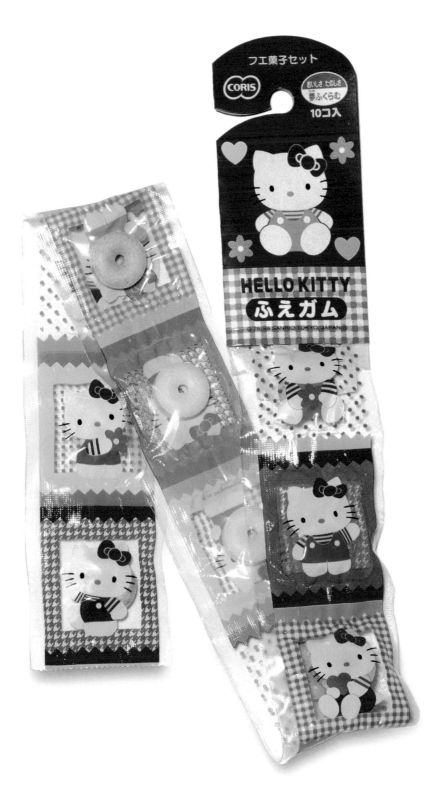

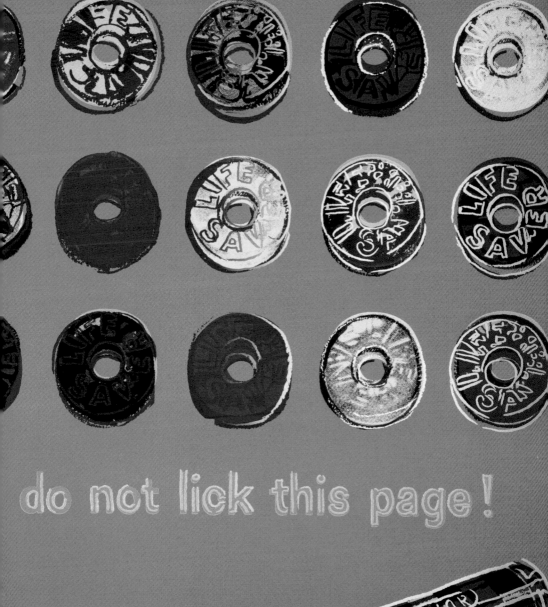

do not lick this page!

e handy roll
verywhere

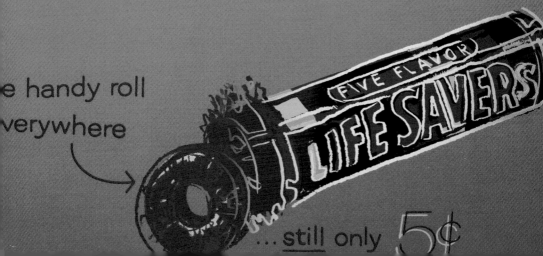

FIVE FLAVOR
LIFE SAVERS

... still only 5¢

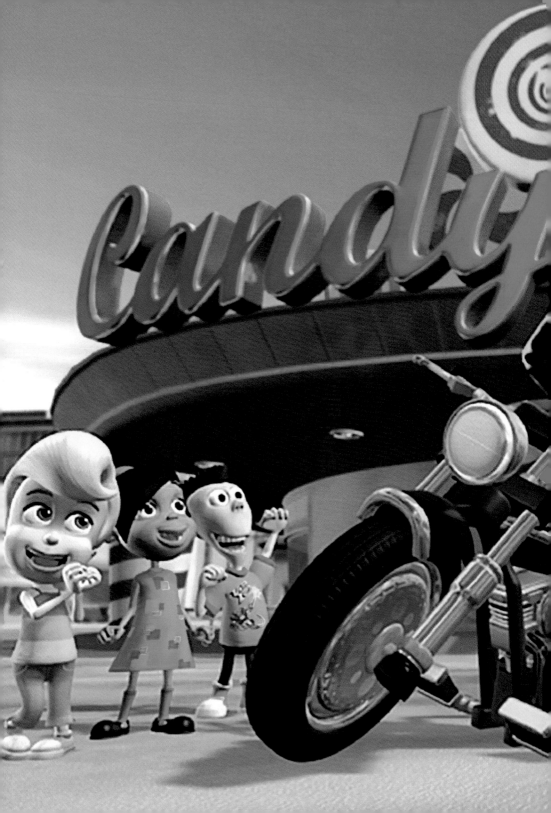

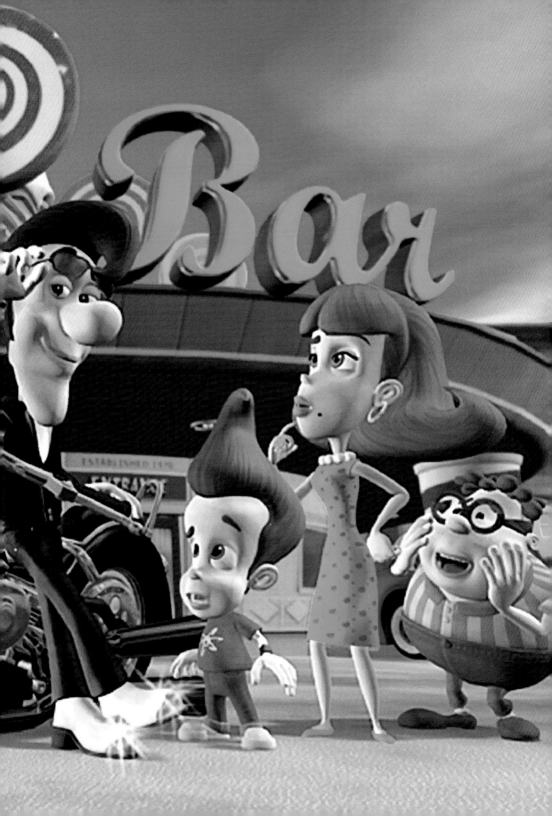

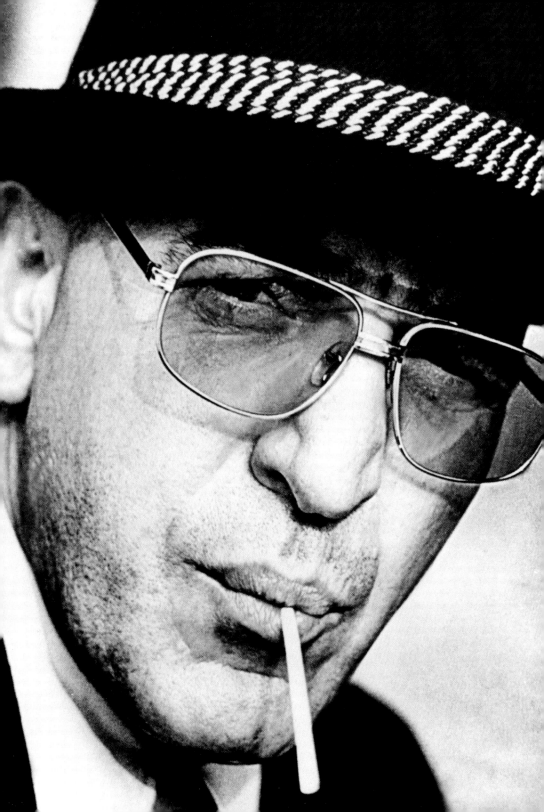

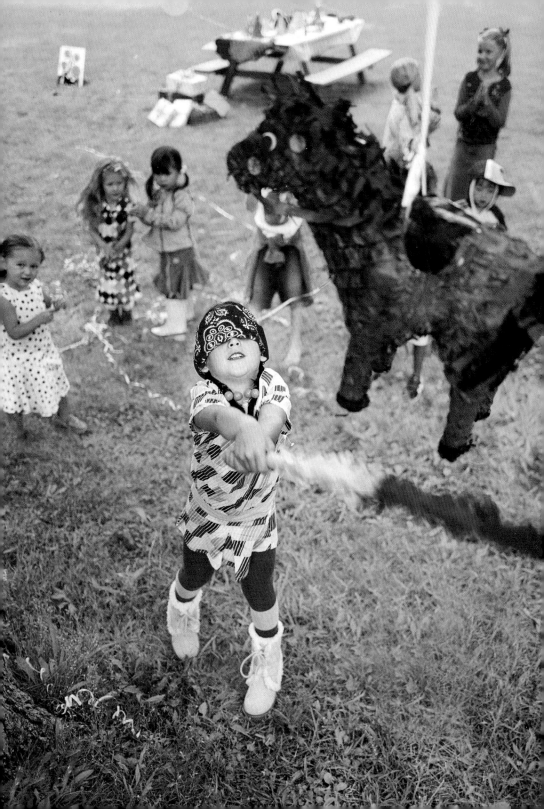

Chronology

1546: First mention of Cotignac (quince paste eaten from small pine boxes) in a book of tales in the Commune of Orléans.

1591: First mention of the candy *Anis de Flavigny*. Benedictine monks first made the sugarcoated aniseed, then Ursuline sisters.

1600: Giovanni Pastilla brings the pastille to France.

1650: Lassagne, Maréchal de Plessis-Pralin's chef, invents the praline.

1750: Pecquet, the Parisian confectioner from Rue de Lombards and King Louis XV's purveyor, perfects the sugared almond.

1760: Georges Dunhill creates the first English licorice candy in Yorkshire.

1792: Theodorus van Haaren creates the Hopje, the famous Dutch hard caramel, in the Hague.

1815: Gilé, foreman at the Lemoine manufacture in Paris, invents candy filled with liqueur. He found the recipe by accident by pouring syrup into superfine sugar.

1825: The Vichy mint is created in Vichy (a city with hot springs).

1830: Gilé invents the *fondant*, the candy that melts in your mouth.

1850: Jean-Frédéric Lillig creates the *Bergamote de Nancy*, the small sugar candy known for its sophisticated flavor.

1851: Gustave Eysseric, the former mechanic in the merchant marines, creates the *Berlingot de Carpentras*.

1865: James Lofthouse creates the Fisherman's Friend in Fleetwood. Sailors used this spicy mint-eucalyptus candy to soothe soar throats.

1866: Francis Fry creates the first dark chocolate bar in Bristol.

1868: Richard Cadbury creates the first box of chocolates in London. The packaging is adorned with a portrait of his daughter, holding a kitten in her arms.

1879: The Frenchman Claude Gaget manufactures the first modern gum in England. Georges Forest begins to fill candy in the center. His *Forestine* had an irresistible almond cream inside.

1880: Léon Lajaunie, the pharmacist from Toulouse, invents the *Cachou*. It was recommended for "smokers, drivers and cyclists."

1882: The American R.S. Murray, who founded his own brand in London, markets the first caramels in England (the ones we know today).

1884: Paul Aubrespy creates the first licorice-based *Zan* candy in Uzès. He later would turn it red.

1896: Leo Hirshfield creates the Tootsie Roll in New York. This is the first penny candy that was individually wrapped for extra freshness.

1898: The Goelitz Confectionary Company in Ohio invents the Candy Corn. This yellow candy shaped like a kernel is nicknamed "chicken feed."

1900: Milton S. Hershey invents the first milk chocolate bar in Chicago.

1903: August Storck creates the eponymous caramel in Werther, Germany.

1905-1914: Wrigley creates Juicy Fruit, Spearmint and Double Mint gum in Chicago.

1912: The chocolate maker Clarence Crane invents peppermint flavored Life Savers in Cleveland, Ohio.
Howell Campbell creates the first bar to combine milk, chocolate, caramel, marshmallow, and peanuts in Nashville, Tennessee.

1917: The brand *La Vosgienne* is created in Menaurupt , France. The main ingredients in the *Sucs des Vosges* are honey and pine sap.
Edward Haas creates Pez dragées in Austria.

1920: Otto Schnering launches the Baby Ruth candy bar in Chicago.

1922: Haribo invents the first gummy bear in Bonn. The candy was shaped in a metal mould.

1923: Franck and Forrest Mars create the Milky Way in Minneapolis, Minnesota.

1924: Pierrot Gourmand invents the French lollipop.

1930's: The Matlow brothers and David Dee (the founders of Swizzels Matlow) create the brand's most popular candies: Navy Mints, Fruit Fizzers, Double Lollies, Parma Violets and New Refreshers.

1930: Mars launches the Snicker bar. The candy family named the bar after their favorite horse!

1931: Tootsie Roll Pops, the first lollipop with a chewy middle, is marketed in the United States.

1932: Van Helle invents Mentos candies in Holland. It would be distributed throughout Europe and then in the United States starting in the 1950s.
The Mars bar is launched in London. Forrest Mars paid shop owners to display the product by the register.

1935: Rowntree launches the Kit-Kat bar in London, using the name Chocolate Crisp.

1936: *Mi-Cho-Ko* is launched.

1937: Rowntree launches Smarties in London.

1941: Mars & Murrie launches M&Ms. They are packaged in cardboard tubes that can be carried around easily.

1948: Rowntree launches Polo mints in England, which look like the American Life Saver.

1952: The former G.I., C.E. Parfet, founds Hollywood Chewing-gum in France. This is the first chlorophyll gum to be manufactured in France.

1954: George Fauchille, the chocolate maker, invents the *Carambar* in Marcq-en-Bareuil, in the Nord region of France.
The Pennsylvania company Just Born comes out with the colorful marshmallow chicks known as Marshmallow Peeps.

1956: Michel Ferrero creates *Mon Chéri* in Italy.

1958: Ce De Candy invents the first candy necklace in the United States.
Enric Bernat launches the *Chupa Chups* lollipop in Barcelona, Spain.
Kréma invents the *Malabar*. The only flavor at the time was tutti frutti.

1960's: The Patrelle company in Houlgate, France, creates meringues called *Boules Coco*.
The *Roudoudou*, a plastic shell with hard candy to suck on, is marketed in France.

1961: Kréma launches *Régal'ad*.

1963: The Sunline Company invents its colorful Sweetarts candy.

1964: Car-Ricqlès, the licorice company, launches bags of licorice dragées called *Car-en-Sac*.

1967: Haribo candies are introduced in France, then in England in 1972.

1969: Ferrero invents the Tic-Tac mint. The small transparent box was developed later.

1974: Ferrero launches *Kinder Uberrashung*.

1975-1980: Haribo invents fruit flavored gumballs named *Dragibus*.

1976: 8 flavors of Jelly Beans are launched, including cherry, root beer, vanilla soda, lemon, orange, green apple, grape, and licorice.
Rowntree launches the Lion bar in England.

1977: Henri Le Roux creates authentic caramels made with salted butter from Brittany (C.S.B) in Quiberon. The delicious flavors were plain, chocolate, hazelnut, orange and even apple *Tatin*.

1978: Hershey launches Reese's Pieces, the peanut butter cups made famous by the movie *E.T.*

1979: Cadbury Roses assorted chocolates are launched in England.

1980: Goelitz manufactures the first gummy bears in the United States.
In Europe, Haribo invents gummy candy in the shape of crocodiles and French fries.

1982: *La Pie qui Chante* launches the *Petit Pimousse*, based on *Régal'ad*.

1988: Kréma launches Kiss Cool. The first flavors were cool mint and mint.

1996: Rowntree creates Giant Color Chanting Sweetarts. They changed color as you ate them.

1998: The American company Light Vision Confections invents the Holopop, the first hologram lollipop that changed with light.

Captions

and photo credits

p. 22: *Confectioner*, c. 1730, print by Johan Friedrich Schmit, Museum of the City of Berlin, Germany. © RMN; p. 23: violet and tulip candy © Assouline; p. 24: marshmallow pyramid. © Sweetiepie (www.sweetiepie.fr); p. 25: candy with messages. © All Rights reserved; p. 26: *rahat-lokum*. © Assouline; p. 27: engraving from *The Book of the Thousand Nights and one Night*, Assouline, 2005. © Léon Carré; pp. 28-29: still from the movie *Charlie and the Chocolate Factory*, Tim Burton, 2005. © Collection Christophe L; p. 30: lollipop. © Getty Images; p. 31: caramel apples. © All Rights reserved; p. 32: caramels. © Assouline; p. 33: poster *"Bonbonnière et Eremitage,"* 1920. © Akg Images; p. 34: Jean Harlow in the movie *Dinner at Eight* by George Cukor, 1934. © MGM/The Kobal Collection; p. 35: heart lollipop. © All Rights reserved; p. 36 (top): advertisement for Altoids. © Courtesy of The Advertising Archives; p. 37 (top): poster "Cachou Lajaunie." © Courtesy of The Advertising Archives; pp. 36-37 (bottom): candy boxes. © All Rights reserved; p. 38: candy saleswoman in the 1950s. © Getty Images; p. 39: candy jar. © Comstock Images/Getty; p. 40: advertisement for Rowntree's, c.1950. © Courtesy of The Advertising Achives; p. 41: fruit drops. © Assouline; pp. 42-43: *Mexican Sculls*. © Magnum; p. 44: advertisement for Mars, c. 1940. © Courtesy of The Advertising Archives; p. 45: chocolate bars. © All Rights reserved; p. 46: trick or treat for Halloween. © Getty; p. 47: Halloween pumpkins. © Corbis; pp. 48-49: still from *Hansel and Gretel* by Len Talan, 1986. © Collection Christophe L.; p. 50: boy in a candy shop. © GDT/Getty; p. 51: candies in herbarium. © All Rights reserved; p. 52: Tootsie Rolls poster. © All Rights reserved; p. 53: Tootsie Rolls. © Assouline; p. 54: cotton candy. © Getty; p. 55: Jackie Kennedy with cotton candy, 1961. © Corbis; p. 57: advertisement for M&M's, 2005. © Courtesy of The Advertising Archives; p. 58: chewing gum bubble. © Corbis; p. 59: candy machine. © Getty; p. 60: candy wrapped in different colors. © Assouline; p. 61: poster *"Menthe Claire."* © All Rights reserved; p. 62: "tongue" candy. © Assouline; p. 63: poster for the movie of *Lolita* by Stanley Kubrick, 1962. © MGM/The Kobal Collection; p. 64: Japanese teenagers. © Magazine *Fruits*, 2001.; p. 65: Hello Kitty candy. © Assouline; p. 66: Dylan's Candy Bar, New York. © All Rights reserved; p. 67: advertisement for Life Savers. © The Andy Warhol Foundation for the Visual Arts/Corbis; pp. 68-69: still from the cartoon *Jimmy Neutron*. © Collection Christophe L.; p. 70: lollipop. © Assouline; p. 71: still from the television series *Kojak*. © Collection Christophe L.; p. 72: children playing with a Pinata. © Joe Vaughn/Getty; p. 73: Penny Candy. © All Rights reserved; p.79: Tigger Pez. © All Rights reserved.

Photographs for Assouline were taken by Philippe Sebirot.

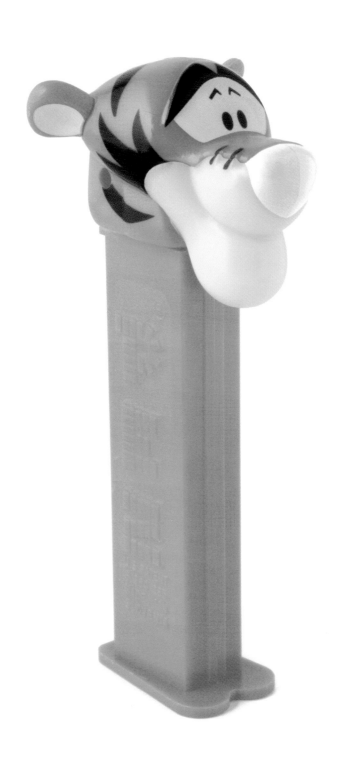

Bibliography

Bonbecs, Anne Rozenblat and Alexandre Révérend, Syros Alternatives, 1991.
Les Bonbons, Philippe Barret and Catherine Amor, Chêne, 1998.
Bonbons et Friandises, Annie Perrier-Robert, Hatier, 1995.
Candy: The Sweet History, Beth Kimmerle, Collector Press, 2003.
Friandises d'hier et d'aujourd'hui, Marie-Laure and Jacques Verroust, Berger-Levrault, 1979.
La Grande Histoire de la pâtisserie-confiserie française, S. G. Sender and Marcel Derrien, Minerva, 2003.
Histoire naturelle et morale de la nourriture, Maguelonne Toussaint-Samat, Larousse, 1997.
Pierrot Gourmand, un siècle de création sucrée, Agnès Besson, Le Cherche-Midi, 2002.
Sweets: A History of Temptation, Tim Richardson, Bantam Books, 2003.

Acknowledgments

The author would like to thank the following people for their direct and indirect contributions to this book: Sébastien Le Fol and François Simon, Denise Acabo (confectioners at *À l'étoile d'or*), Maguelonne Toussaint-Samat, Mélina Dupont (Cedus), Corinne Monteil (Haribo France), Berry Howard, Daniel Noury (Masterfoods), Pascale Infante and Valérie Le Goff (Cadbury France), Carole Vivien (Chupa Chups France), Steve Dolfi (confectioner at *À la mère de famille*), Fabrice Gay, Anthony Palou and Florence Hallier, Nicolas d'Estienne d'Orves, Anne N'Guyen Khac, Delphine Ribouchon, Antoine Barat, Myriam Jeuffroy, Philippe Jung, Philippe Guillonneau and Lucienne Denost.

We would also like to thank the photographer Philippe Sebirot as well as the photo agencies: Akg-images, RMN, Corbis, Getty-images, Picture Desk, Bridgeman Art Collection and also public relations at Haribo, sweetpie.fr, Dylan's Candy Bar, Cécile Bouvet and Céline Saurel.